Inspirational Scrapbooks

Heritage

Edited by Joy Aitman

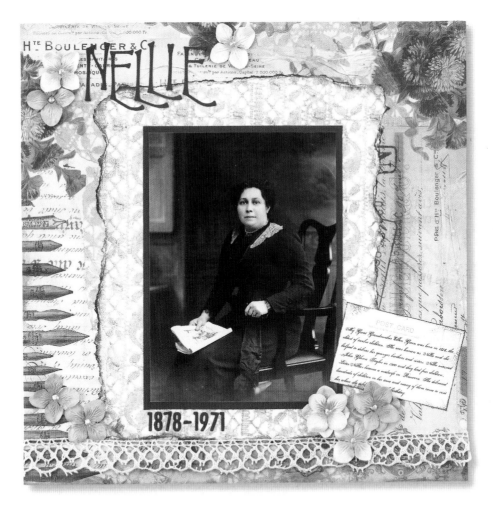

SEARCH PRESS

First published in Great Britain 2007

Search Press Limited
Wellwood, North Farm Road,
Tunbridge Wells, Kent TN2 3DR

Text copyright © Joy Aitman 2007

Photographs by Roddy Paine Photographic Studios

Photographs and design copyright © Search Press Ltd
2007

ISBN-10: 1-84448-180-8
ISBN-13: 978-1-84448-180-4

The Publishers and authors can accept no responsibility
for any consequences arising from the information, advice
or instructions given in this publication.

Readers are permitted to reproduce any of the items/
patterns in this book for their personal use, or for the
purposes of selling for charity, free of charge and without
the prior permission of the Publishers. Any use of the items/
patterns for commercial purposes is not permitted without
the prior permission of the Publishers.

Suppliers

If you have difficulty in obtaining any of the materials and
equipment mentioned in this book, then please visit the
Search Press website for details of suppliers:

www.searchpress.com

Acknowledgements

*Thank you to my talented design team who
have made this book possible:
Kate Aldersley, Mandy Anderson,
Jane Cotter, Alison Docherty, Becks Fagg,
Sarah McKenna, Katie Shanahan-Jones
and Kirsty Wiseman.*

The front cover shows *Coronation* by Kirsty Wiseman (see
page 26).

Contents

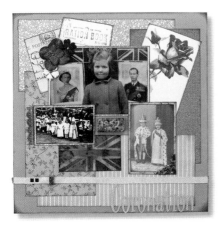

page 26

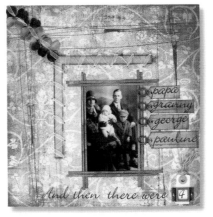

page 28

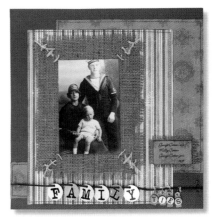

page 30

Introduction

Researching your family tree can be a labour of love. It is a time-consuming job and it can be a solitary search. Scrapbooking your pictures is an ideal way to show your results to the rest of the family. You can make your family story more accessible with pictures, letters and memorabilia. You can illustrate the stories you have collected for future generations. These stories can easily be lost if not recorded, so it is very rewarding to become the family historian and preserve the past.

Everyone has old family photographs somewhere in their home. These can become meaningless if they have no stories to go with them. Dig them out and start the process. Find memorabilia to go with them or embellishments that match the period. Chat to relatives and listen carefully to their stories.

Use this book to inspire you. There are lots of ideas for different eras, and tips and techniques to help you produce beautiful scrapbooks. Once you start you will want to dig for more and more information. Good luck with the search.

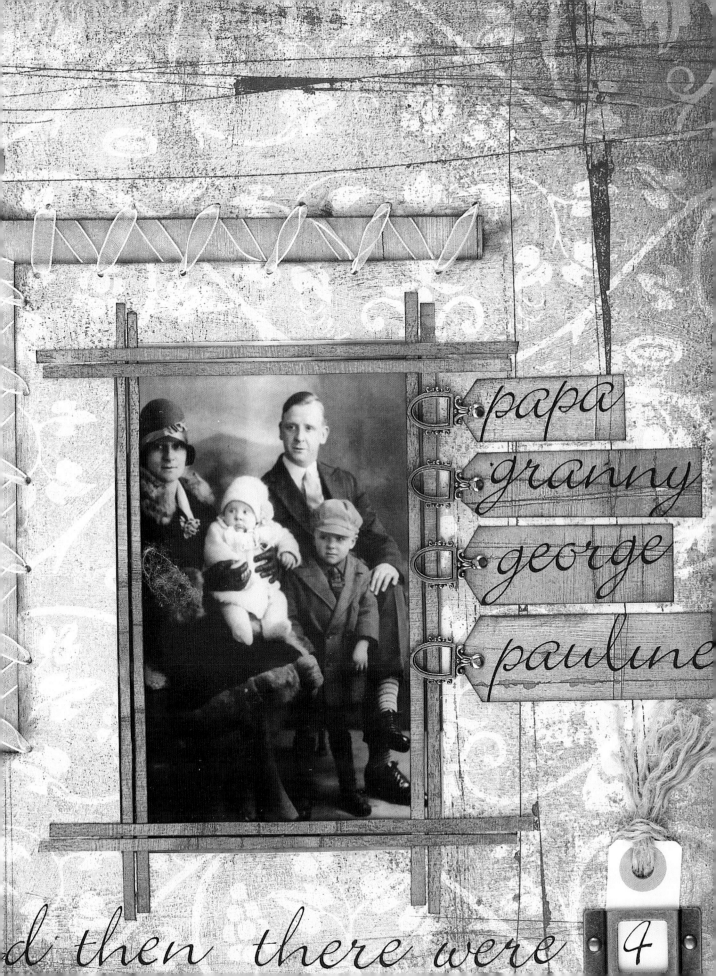

papa

granny

george

pauline

d then there were 4

Hello Campers

Joy Aitman

Holiday camps were all the rage in the 1960s. These pages capture the essence of the holiday and provide information about the times.

Using memorabilia can add extra information to the pages and make them more exciting than with photographs alone. Tickets, leaflets, postcards and advertisements may have been saved, but these are things that are often lost over time. If you do not have the original memorabilia, look on the internet – you will be amazed by what you can find there.

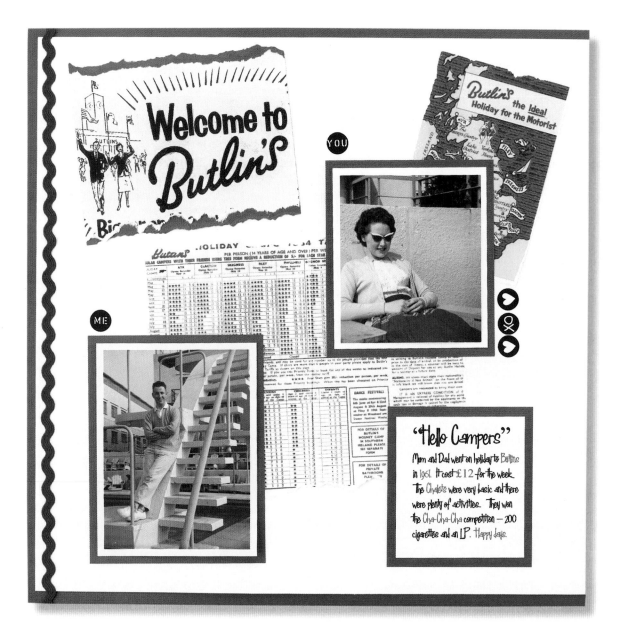

On this scrapbook page, leaflets and posters have been used as a background. Print them at best quality on to smooth card, then tear the edges. Mount the torn printouts on red card to make them match the rest of the layout.

Referring to memorabilia can also help you choose fonts and colours to suit the period. Once you have found information on the internet, decide how you are going to use it. Print your postcards and pictures on to photographic paper, as this will improve the quality.

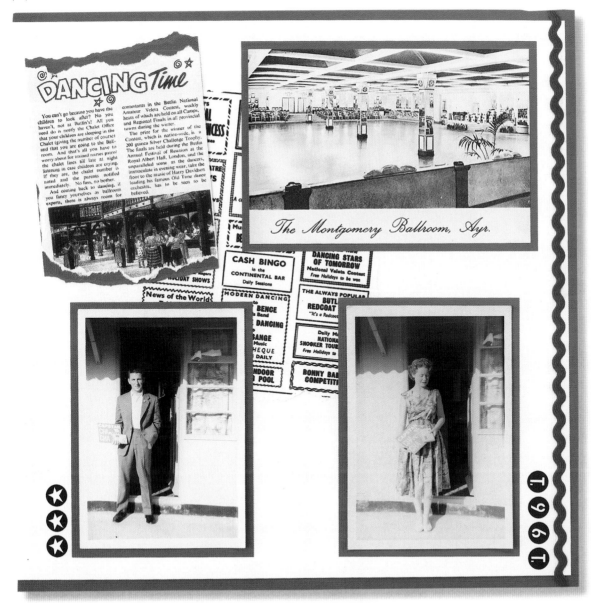

Preserve the Past

Jane Cotter

This layout features a treasured photograph of a grandmother as a young girl.
It is a simple collaged page with the photograph printed on to fabric. Sometimes a
treasured photograph can be a little blurred or faded and printing it onto fabric can
enhance it.

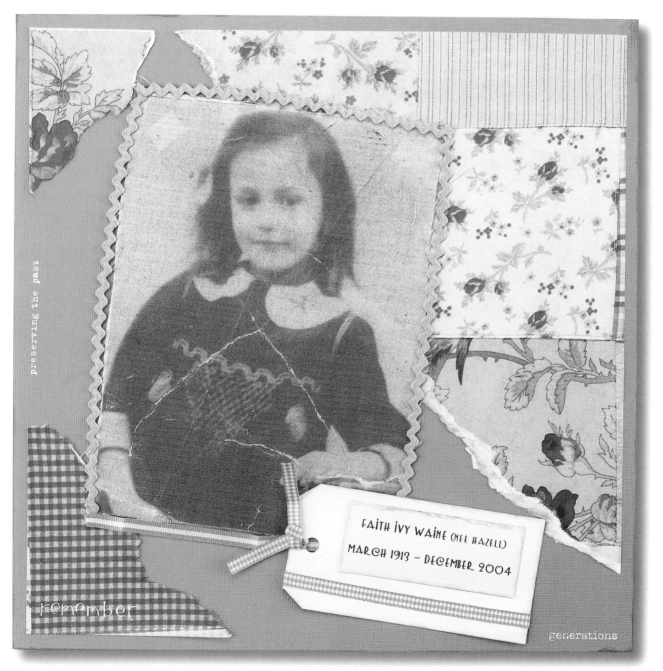

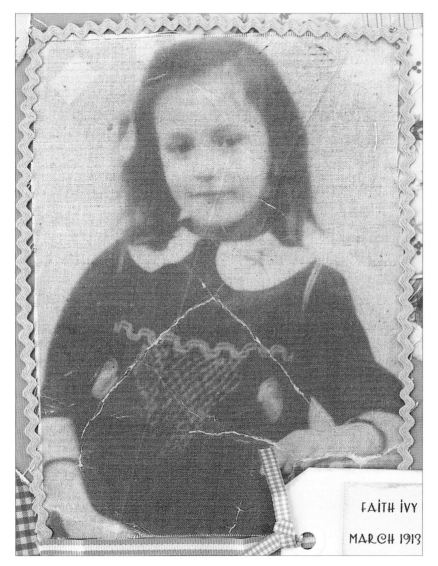

FAITH IVY

MARCH 1913

A plain, washed and ironed calico is the easiest fabric to print on to. Firstly, scan your photograph. You can then edit it as you desire. Take an A4 piece of fabric and attach it to your A4 printer paper using double-sided tape. Place the tape close to the edges to prevent the fabric ruffling up. Make sure there are no loose threads that could wrap around your printer rollers. Print your photograph on to your fabric. Let your ink dry thoroughly before putting your page together. Attach the fabric using spray adhesive, following the usual safety rules.

Heirlooms

Jane Cotter

This page shows Great, Great Grandma and her five children, one of which is Great Grampie.

It can be difficult to find suitable embellishments to go with very old photographs. However, many manufacturers produce a variety of pieces that fit very well with different periods. Many of these have words printed or embossed on to them, which make them suitable for titles.

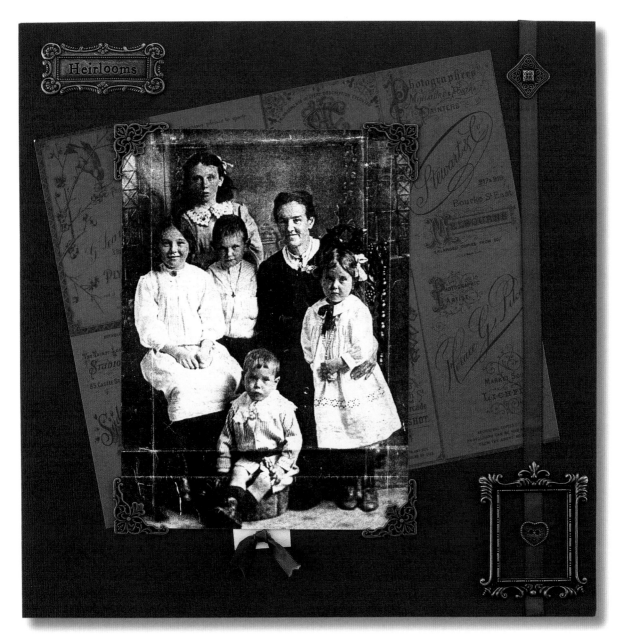

This metal title fits perfectly with the period feel being created in this layout. To attach metal embellishments, use a suitable adhesive. Use it sparingly so that it does not spread on to the pages. It is best if you apply the glue to the embellishment and allow it to become tacky before pressing it on to the page.

Journaling is an essential part of heritage scrapbooking. You want to make sure you record as much information as possible. However, sometimes a lot of journaling on a page can make it look cluttered. The way round this is to create hidden journaling, as shown here.

Print or handwrite your journaling on to a tag. Punch a hole in the tag and tie on a piece of ribbon to match your layout. Slide the tag behind your photograph. Make sure the ribbon is visible, as you will want people to realise that the journaling is there so that they can pull it out and read it.

A Life Spent in Service

Katie Shanahan-Jones

Many families have had military personnel in them at some time. Military pages should be subtle and in keeping with their subject.

By using collage on a page you can create your own unique background, evoking the time period you need to go with the photograph you are using.

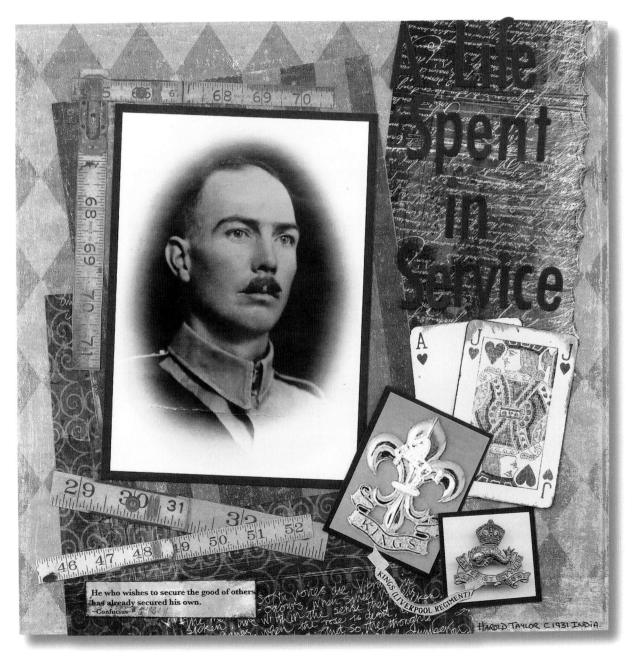

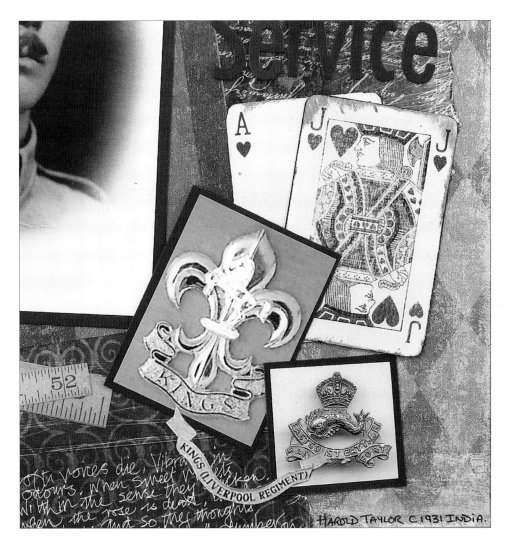

To create a suitable collage, choose a selection of papers and ephemera that have a heritage look to them: here, playing cards, regimental insignia and tape measures have been used. Age the papers by tearing and inking the edges. Remember to tear patterned papers towards you if you want to expose the white layer beneath the surface. Layer the papers until you are happy with the look. To soften the edges of your playing cards, drag a chalk inkpad around the edges. The playing cards are glossy so will take a while to dry. Add to the page along with the other memorabilia.

David

Katie Shanahan-Jones

The history of a man's youth told with maps, letters and photographs.

Sometimes using black and white photographs can be a little bland. A hint of colour can add more interest. This used to be done professionally but you can achieve the look yourself by adding coloured ink, as shown on the boy's tie. The addition of colour here brings the whole page to life.

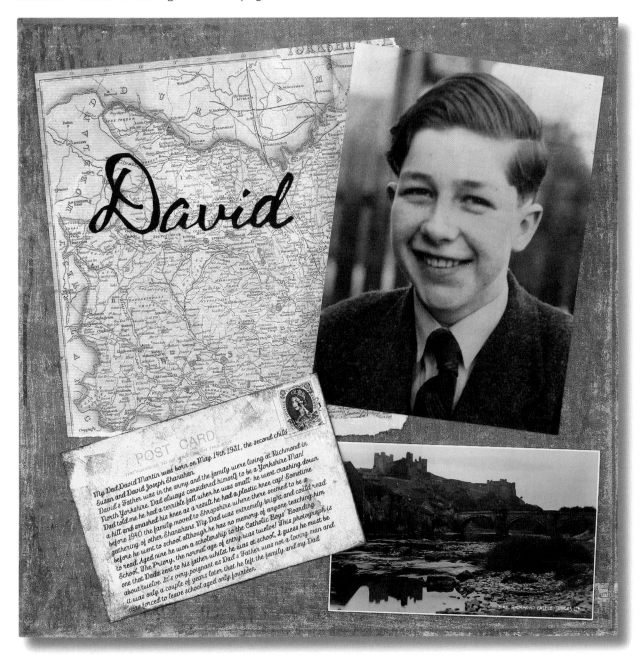

My Dad David Martin was born on May 14th 1931, the second child of Susan and David Joseph Shanahan and the family were living at Richmond in North Yorkshire. Dad always considered himself to be a Yorkshire Man! David's Father was in the army, and the family were living at Richmond in Dad told me he had a terrible fall when he was small; he went crashing down a hill and smashed his knee as a result he had a plastic knee cap! Sometime before 1940 the family moved to Shropshire where there seemed to be a gathering of other Shanahans. My Dad was extremely bright and could read before he went to school although he has no memory of anyone teaching him to read. Aged nine he won a scholarship to the Catholic Boys' Boarding School, The Priory, the normal age of entry was twelve! This photograph is one that Dada sent to his father whilst he was at school, I guess he must be about twelve. It's very poignant as Dad's Father was not a loving man and it was only a couple of years later that he left the family, and my Dad was forced to leave school aged only fourteen.

You can colour your photograph using alcohol inks. These come in a wide variety of colours and are easy to apply.

Make a copy of your original photograph, in case of errors. Decide on the colour you wish to use. Do not use anything too bright as it is best to choose subtle shades for heritage projects. Pour out a little ink into a saucer. Use a fine brush and paint the ink on to your chosen area. You only need a small amount of ink so do not overload your brush. The ink dries very quickly but do take care to avoid smudging the work.

Larger areas can also be coloured with art chalks. Apply these with a cotton bud. The colour is very pale but can be effective. Shake off any excess powder and leave to dry for at least twenty-four hours before working with the photograph.

Nellie

Katie Shanahan-Jones

A dark photograph can benefit from the use of patterned paper. The lace border used here echoes the lace in Nellie's collar, and the flowers add a very feminine touch.

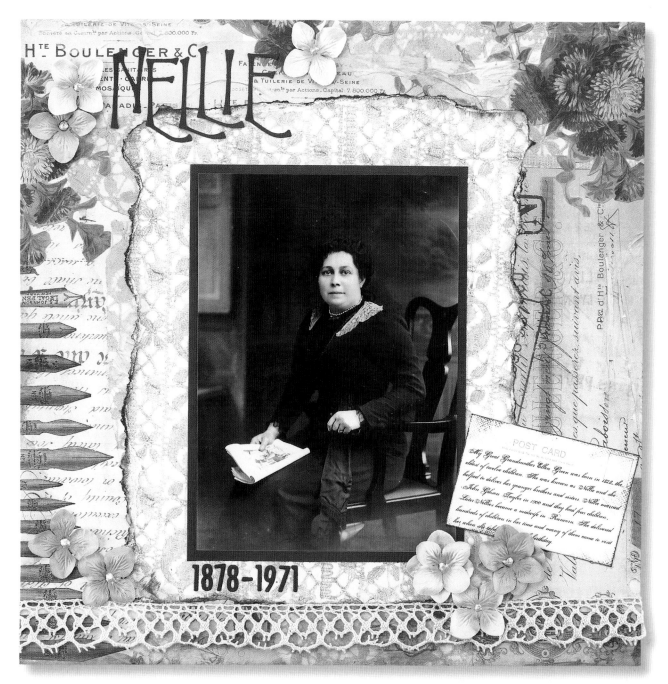

There is a huge variety of patterned paper available and it is especially important to select well when working with heritage photographs. Bright, bold patterns can completely overshadow the photograph. Choose softer colours and floral or script patterns. Help yourself in matching colours by using patterned papers from the same set. Different patterns work together as long as the colours sit well together. Age the papers with chalk ink, as this also softens the transition from one pattern to another. If the patterned paper has a suitable motif, cut this from the paper and add it to your page.

India

Katie Shanahan-Jones

The Taylor children stand to attention for their photograph. The exoticism of India is brought to the page with hand-cut and stamped motifs, coins and stamps.

 If you cannot find suitable motifs for your layout, you can make your own. Hand-cut images always look impressive and are easy to do with a steady hand.

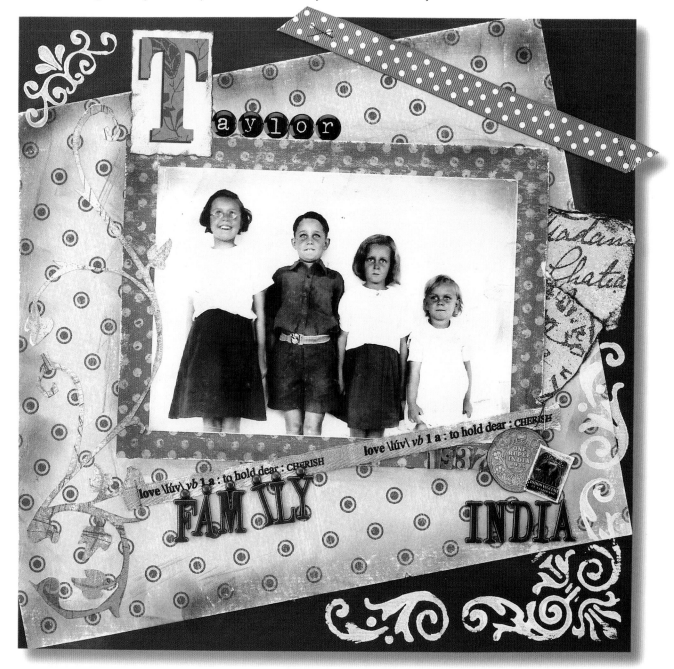

Select a scroll dingbat on your word processing package. You can find these images free on the internet. Alter the size until it fits your scrapbooking page. Print the dingbat, in outline, on the reverse of your patterned paper. Use a repositionable adhesive to attach your printout to your cutting mat and use a craft knife to cut out the image. Take your time and always make sure your blade is sharp. Twist the mat round to make awkward corners easy to cut. This is easier than twisting your arm!

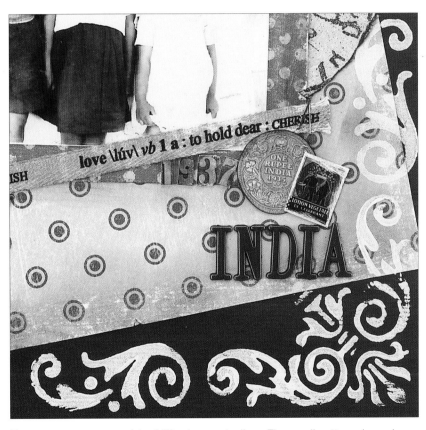

Foam stamps are a useful addition to your toolbox. The scroll pattern shown here reflects the hand-cut scroll on the left of the layout. Use acrylic paint to get a bold image. Brush the paint on to the stamp neat, without watering it down. Make sure the paint is spread evenly. Press the stamp on to your page. The paint can be quite slippery so take care not to smudge your image. Allow the paint to dry fully.

The Sisters Harrison

Kirsty Wiseman

This portrait of four sisters is displayed on a wonderfully feminine page. This layout can be described as 'shabby chic'. It combines aged papers with lace, hatpins and flowers, all of which are reminiscent of the time.

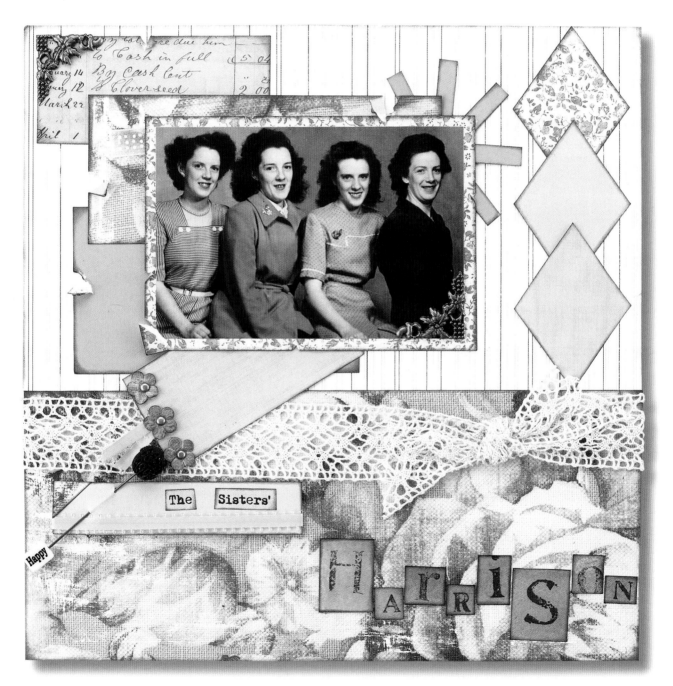

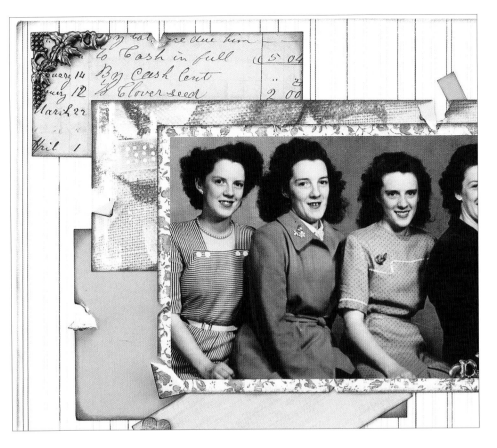

Rather than tearing all the way around the papers, tear a small piece out of the edge. Fold back some of the tears or leave a corner hanging loose. This gives a more subtle look. Double-sided papers are ideal for this. Take your time and tear slowly to prevent over-ripping.

Customise small pieces of jewellery or haberdashery on your page. Stick or hatpins can often be picked up in charity shops and are ideal for attaching titles. Add coloured beads or ribbons to make them match your layout. Relatives may even be able to provide you with original pieces of costume jewellery to use as embellishments.

Elfreda

Kirsty Wiseman

Elfreda has the look of a movie star and looking at this page you really want to
know her story. All of which is tucked away, on tags, in small envelopes.

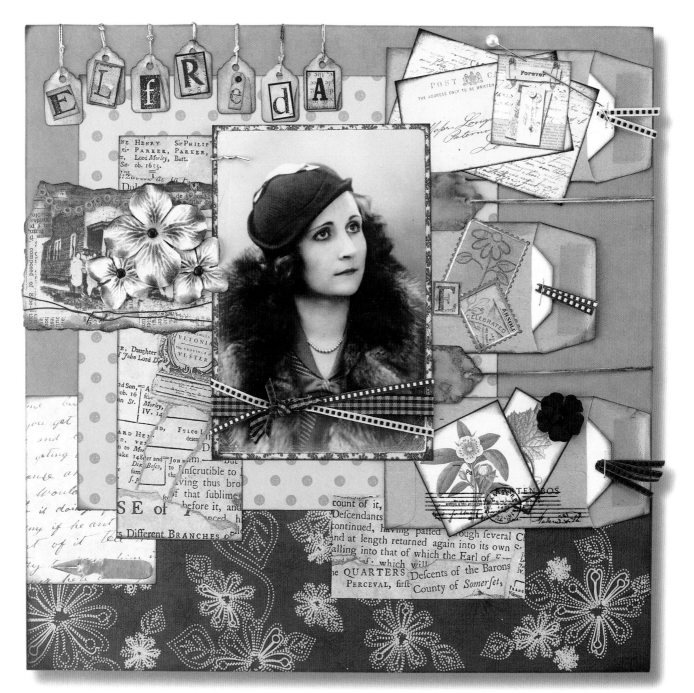

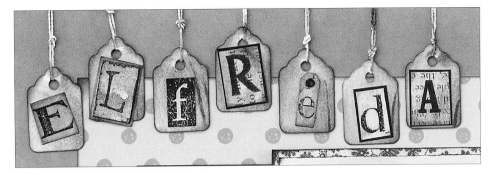

Create an unusual title using mini-tags. Use pre-cut tags or cut out your own. Ink your tags with chalk or walnut inks to give them an aged look. Print out the letters for your titles in a variety of fonts. Choose your fonts to match the era. Cut out the letters in blocks and add to your tags. Tie inked string to the tags and attach them so that they hang over the top edge of the layout. Hang them at different heights to give them a random look.

Flowers on a layout give a very feminine look. Use paper, silk or ribbon flowers in groups or on their own. It can be difficult to match the colours of the flowers to your layouts, however you can customise them with chalk inks. Hold the chalk inkpad upside down and brush it over the flowers, varying the pressure to get different depths of colour.

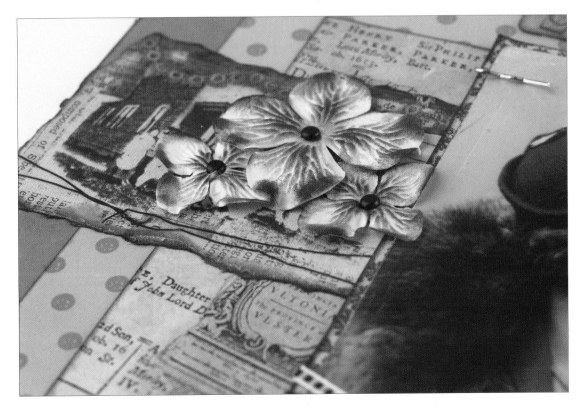

Home Guard

Kirsty Wiseman

This page details Fred's time in the Home Guard during the Second World War. A file folder is used for the journaling, which looks like an official document and adds to the period feel of the layout.

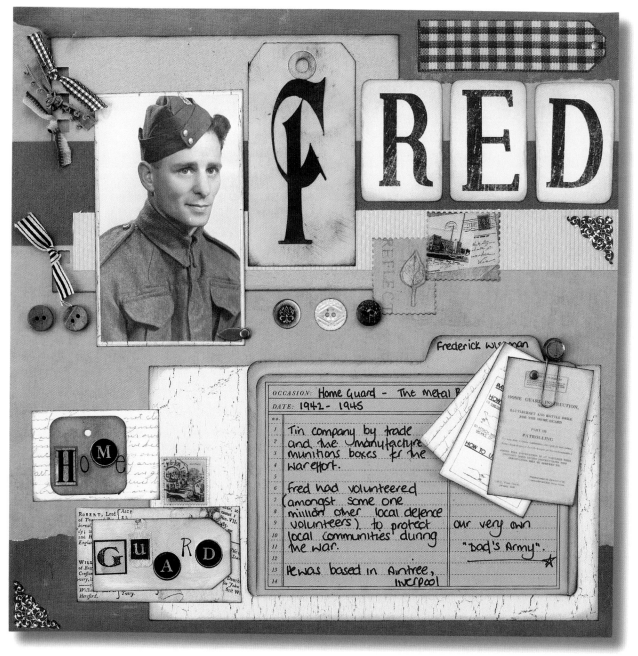

FRED

RED

File folders are ideal for holding your journaling. They come pre-made in a variety of sizes and colours, or you can make your own. They are useful if you have a lot of journaling as you have space both on the outside and the inside of the folder. You can make them look very official by typing the information or more informal by handwriting. They can also hold additional photographs or documents. Embellishments can be added with official-looking clips and pins. You can ink the edges to make them match the aged look of your page.

Frederick Wiseman

The Local Defence Volunteers were formed in 1940. Their job was to defend the country in case of invasion and later in the war they crewed anti-aircraft (Ack Ack) rocket batteries. The name was eventually changed to 'Home Guard' and volunteer numbers never fell below one million. Members were aged between 17 and 65 and mainly in reserved occupations. Approximately 40% were experienced soldiers who had served in the First World War. Towards the end of the war the Women's Home Guard Auxiliaries were formed and worked in an administrative capacity, with the Home Guard

most of the volunteers for the home guard did their drill training in civilian clothing and used real artillery. (although pitchforks were used!)

Coronation

Kirsty Wiseman

Most families have a story of how they celebrated or viewed the Coronation of Queen Elizabeth in 1952. This page combines photographs and memorabilia to recreate the atmosphere of the big day.

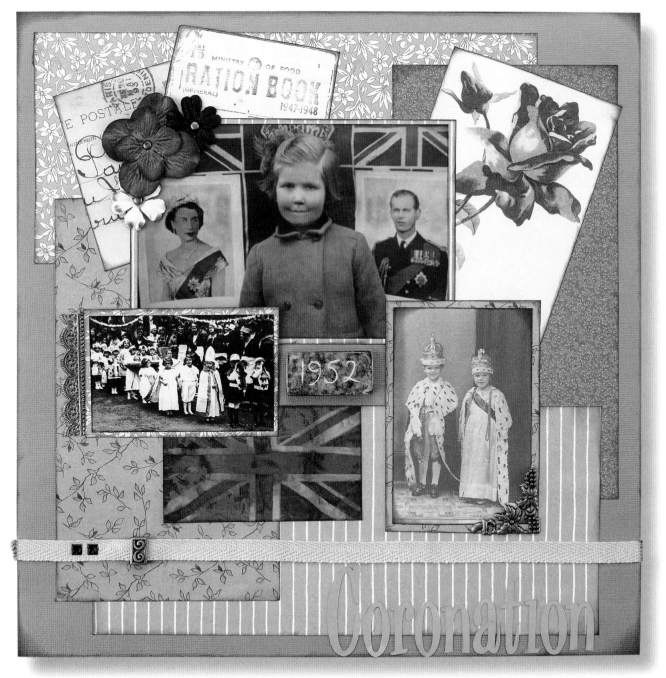

This most unusual date embellishment has been created from a soapstone domino. The soapstone is soft and easy to carve. Write the date on the domino with a soft pencil. This will give you a guideline to follow. Use a paper piercer or similar tool to scratch into the stone. Take your time to gradually scrape away the layers. If you are scratching into a light-coloured stone, you can highlight the carving using walnut ink. Wipe the ink over the stone using a soft cloth and the ink will soak into the exposed carving.

And Then There Were Four

Mandy Anderson

This unusual frame of ribbon and flowers softens a rather formal-looking family portrait, and adds a feminine touch to the layout. The colours of the silk flowers enhance the sepia tones of the photograph.

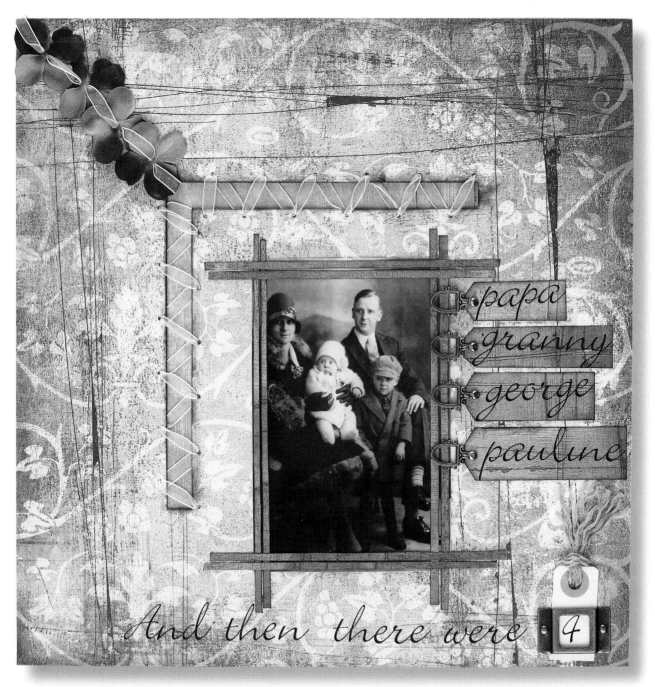

Cut two small slits in the centre of each silk flower. Thread the ribbon through the slits to create a chain of four flowers. Attach the chain with double-sided tape across the corner of the layout.

Opposite

The L-shaped frame for this photograph has been created by marking an 'L' in pencil. Cut the frame out with a craft knife and metal ruler. Ink around the inside edges of the 'L'. Pierce holes around the outside edges of the frame. Use a large darning needle to thread your ribbon through the holes in a zigzag pattern. Secure the ribbon on the back of the layout with double-sided tape.

Family Ties

Mandy Anderson

The title of this layout is taken quite literally in the embellishments, some of which are tied on! Fibres are used to create very simple but effective embellishments on this page.

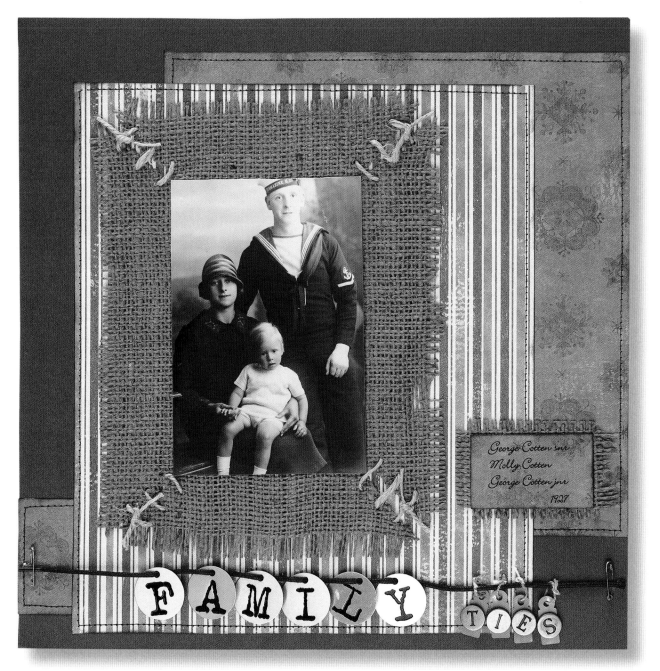

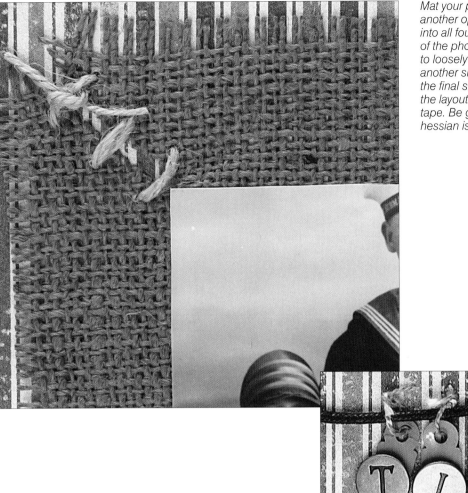

Mat your photograph on to hessian or another open-weave fabric. Cut a slit into all four of the corners, just short of the photograph. Use rough twine to loosely stitch across the slit. Tie another short piece of twine around the final stitch and cut short. Attach to the layout using strips of double-sided tape. Be generous with the tape as the hessian is quite heavy.

Use the same twine to tie the title tags to the layout, spelling out the word 'TIES'.

Arnhem Heroes

Mandy Anderson

This is a very special, moving layout, celebrating the bravery of this band of soldiers. Copies of original wartime newspapers have been collaged to create an unique background for the photographs. Even the original uniform badge is included – the ultimate embellishment.

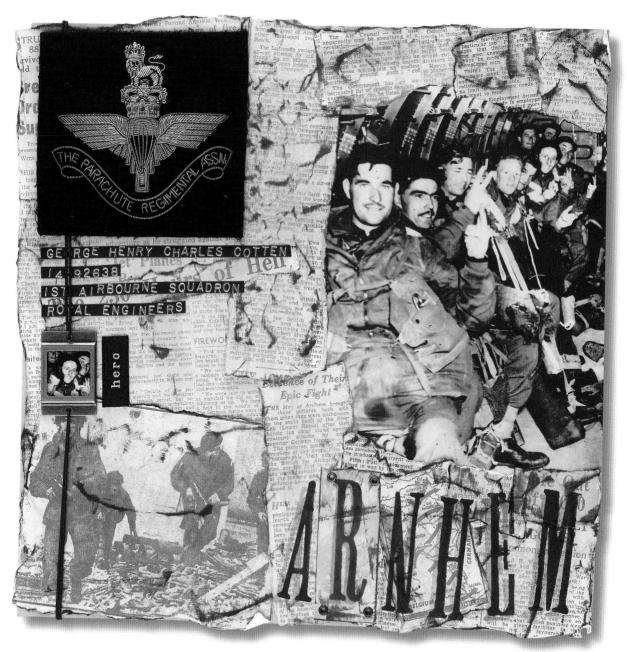

To highlight the main subject in the photograph, in this case George Cotten, cut his head and shoulders from a copy of the photograph and frame it with a metal label holder, or similar. Attach it to the layout using ribbon. Add the journaling with plastic tape labels.

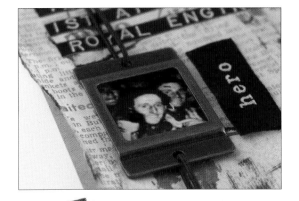

The title has been stamped using foam letter stamps and ink. The ink sits better on the newspaper background than acrylic paint. Some of the letters have been stamped on separate pieces of cardstock and attached to the page using eyelets.

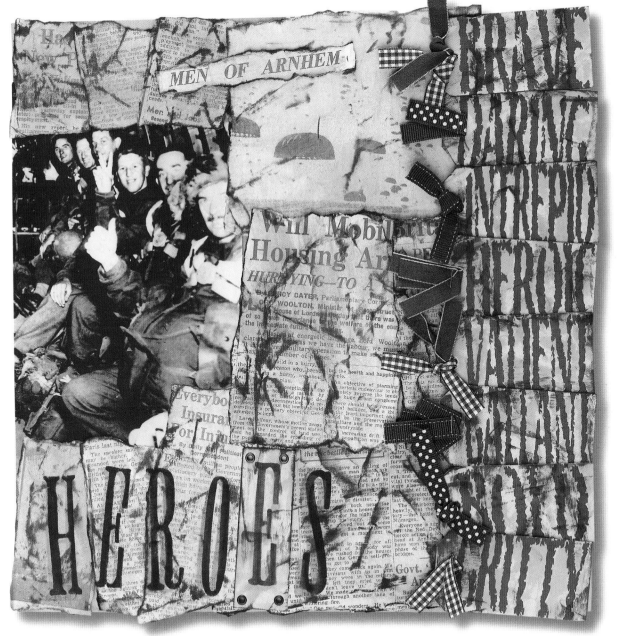

Grandpa

Sarah McKenna

A nostalgic look at a day on the river with Grandpa, who was a boatbuilder on the Thames and had the honorary title of Queen's Waterman. Memories of Grandpa are printed on to strips of card and hidden under the title flap.

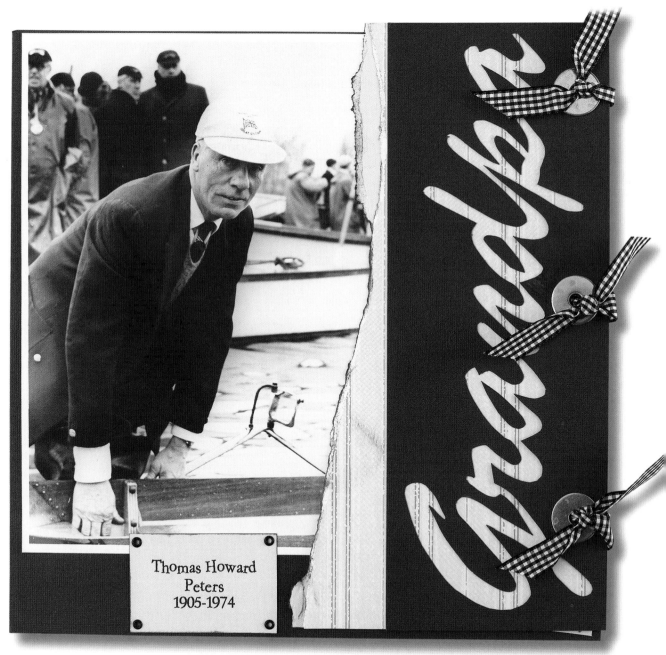

Thomas Howard
Peters
1905-1974

The metal embellishments on this page serve two purposes, firstly decorative: they are masculine and tie in with the boating theme. Secondly they have a functional purpose, in that they anchor the ribbon that is used to secure the flap for the hidden journaling. The washers are ordinary washers from a hardware shop. They have been attached to the flap with glue to provide a reinforcement for the punched holes.

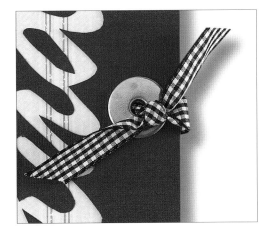

The title for this page has been created on a flap that folds back to reveal hidden journaling. Make the flap using a straight-cut piece of cardstock backed by a larger piece of patterned paper. Tear the patterned paper at an angle and ink it. Punch three matching holes through the flap and the page. Tie the flap on with complementary ribbon. Print your typed journaling on to strips of card, brush them with blue ink and staple them to the layout.

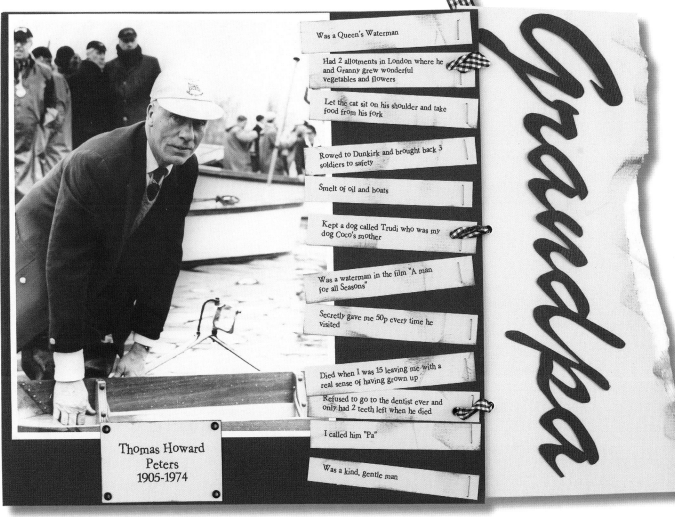

Was a Queen's Waterman

Had 2 allotments in London where he and Granny grew wonderful vegetables and flowers

Let the cat sit on his shoulder and take food from his fork

Rowed to Dunkirk and brought back 3 soldiers to safety

Smelt of oil and boats

Kept a dog called Trudi who was my dog Coco's mother

Was a waterman in the film "A man for all Seasons"

Secretly gave me 50p every time he visited

Died when I was 15 leaving me with a real sense of having grown up

Refused to go to the dentist ever and only had 2 teeth left when he died

I called him "Pa"

Was a kind, gentle man

Thomas Howard
Peters
1905-1974

Grandpa

Boys and Their Toys

Sarah McKenna

Martin shows off his favourite tricycle on this fun page. Nuts and washers make ideal embellishments for the theme of the page, giving it a masculine look and hinting at a love of all things mechanical.

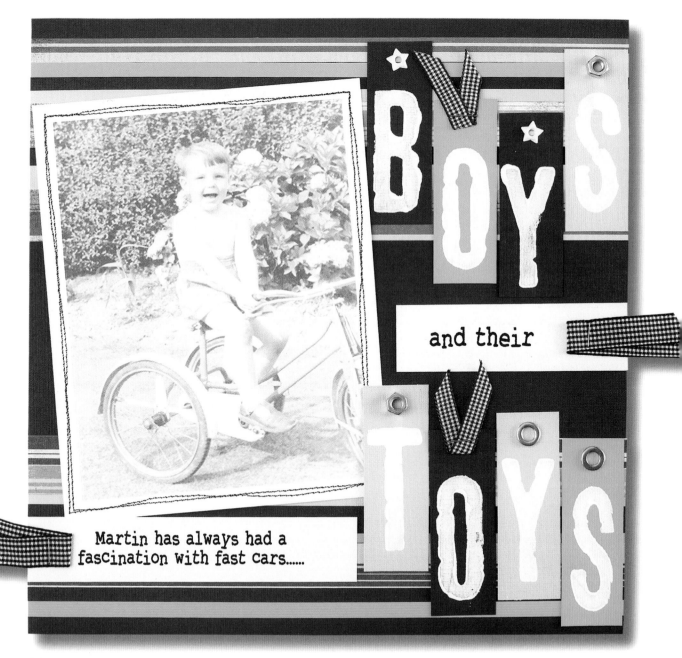

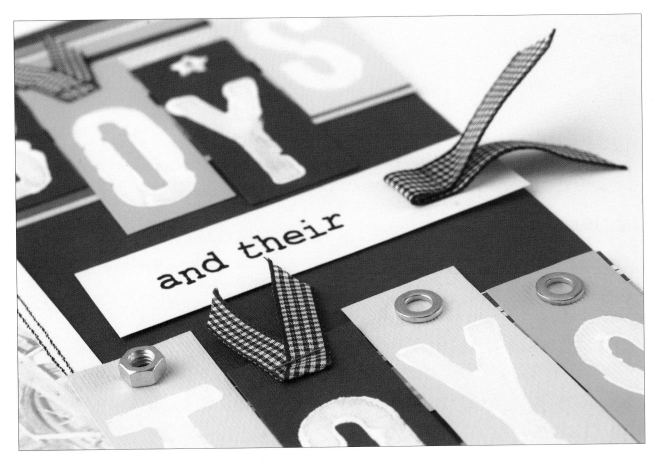

Stamp the title using foam stamps and acrylic paint. White paint stands out boldly against the dark-coloured cardstock. Stamp some of the letters on to the rectangles of coloured cardstock and the others directly on to the layout. Embellish the letters with metal nuts and washers from your local hardware shop. Use an adhesive which will cope with their additional weight. Add ribbon to the 'O's to turn them into tags. Attach them to the layout.

Little Girl

Alison Docherty

A secretive smile from a young girl, whose story is told in a mini-book. This page, using coordinating patterned paper, would have been cluttered by the addition of extra photographs and text, so additional elements are in the mini-book.

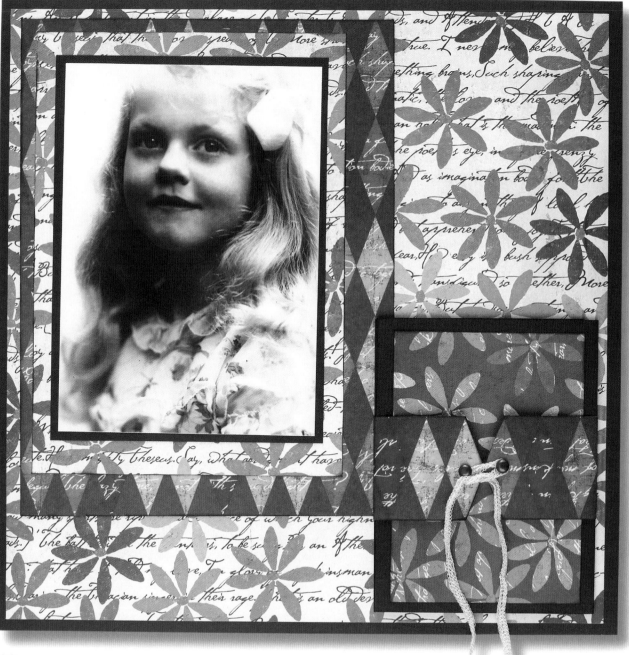

Create a concertina mini-book to add extra photographs and journaling. Choose matching cardstock to make the book and decorate with the coordinating papers used on the layout. Add a strip of paper to wrap around the back of the mini-book page that attaches the book to the layout. Add eyelets to either end of the strip so that ribbon can be tied through the holes to keep the book closed. The book can be made with as many pages as necessary. Consider adding pockets to the book so that you can include even more information. Pockets are extremely useful for copies of documents like birth or marriage certificates.

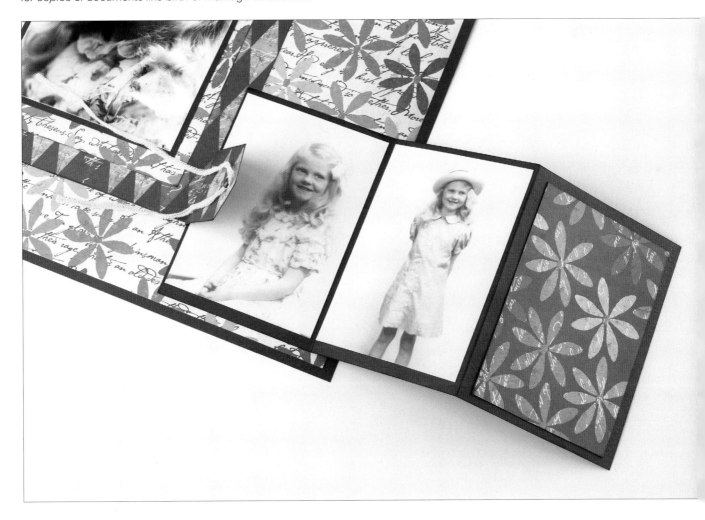

I Have a Question

Becks Fagg

This layout features all those questions you wish you could go back in time and ask. The journaling consists of a list of questions for Grandad, which makes it very personal and emotive. It has been printed in a font that looks like handwriting. If you are comfortable with your own handwriting, use it, but practise first so that you can work out your spacing. Use your sewing machine to add some decorative stitching to your block of journaling.

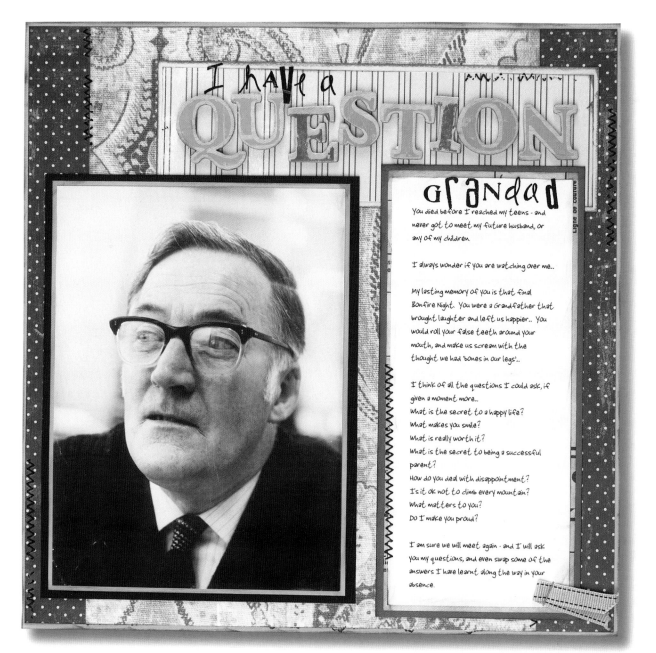

Create a title using a variety of lettering techniques. Sand the wooden or chipboard letters to give them an aged look and glue them on to the page. Use these large letters to single out one word in the title only, so that they do not take up too much room and dominate the page. Use rub-on transfers in a variety of fonts to complete the title.

Scenes From Your Youth

Becks Fagg

Here the title, patterns and embellishments chosen evoke the particular era in which these boys were young.

Large titles and journaling can be created in a variety of different ways. Stickers and pre-cut monograms are quick and effective and can be found to match the patterned papers that you choose.

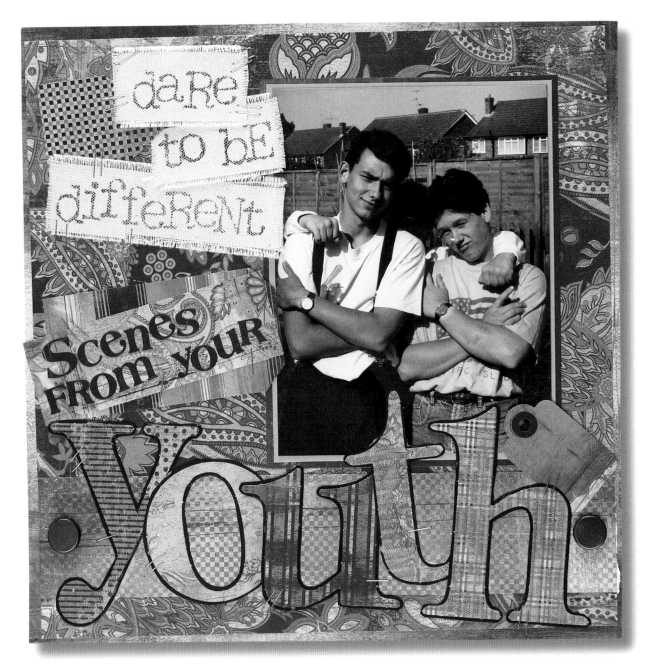

Create a slightly different title by stamping on to calico. Cut the calico into strips. Fray the edges slightly. Iron the strips flat. Use a mix of upper and lower case stamps, and ink that matches your paper, to stamp out your title. To prevent the ink bleeding, do not over-ink your stamps and stamp lightly. Allow the ink to dry before attaching the calico to your layout with double-sided tape.

Kirkcaldy

Kate Aldersley

Do not confine your layouts to your scrapbook, display them on a canvas on your wall.
These canvases are bought pre-stretched on a frame and ready for you to decorate.

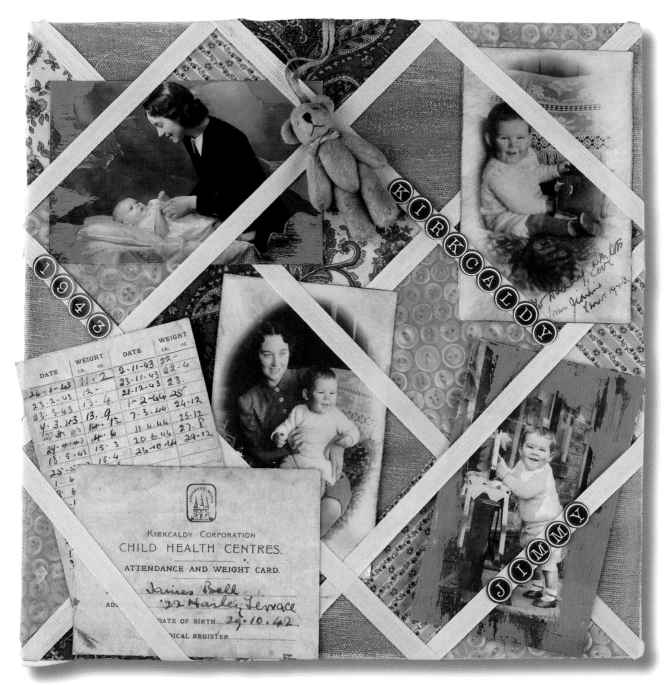

Paint your blank canvas with acrylic paint to match your papers and fabrics. Don't forget to paint the sides. Attach papers and fabrics as your background. Wrap and pin ribbon in a criss-cross fashion over the canvas. This creates a lattice for you to slip your photographs and memorabilia into. You will also need to use photo tabs to provide extra hold.

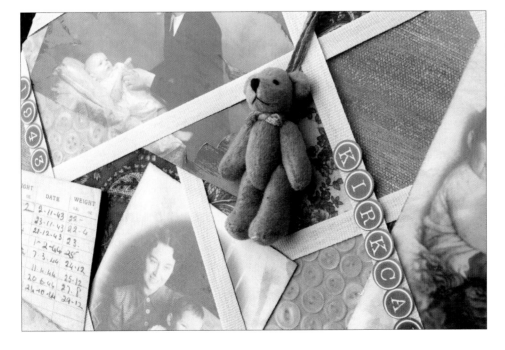

As your canvas is going on the wall, you can add bulkier embellishments than you would normally use on a page meant for an album. This mini-teddy bear adds a special touch to a baby layout. You could also use bootees and bonnets. The title has been created from pre-made letters that are attached along the ribbon to make them stand out more clearly.

Mary Haddow

Joy Aitman

This layout shows Grandma with her much-loved doll's pram. The photograph has been printed on to fabric, and this has then been machine sewn on to a cardstock mat before being stuck on to the layout.

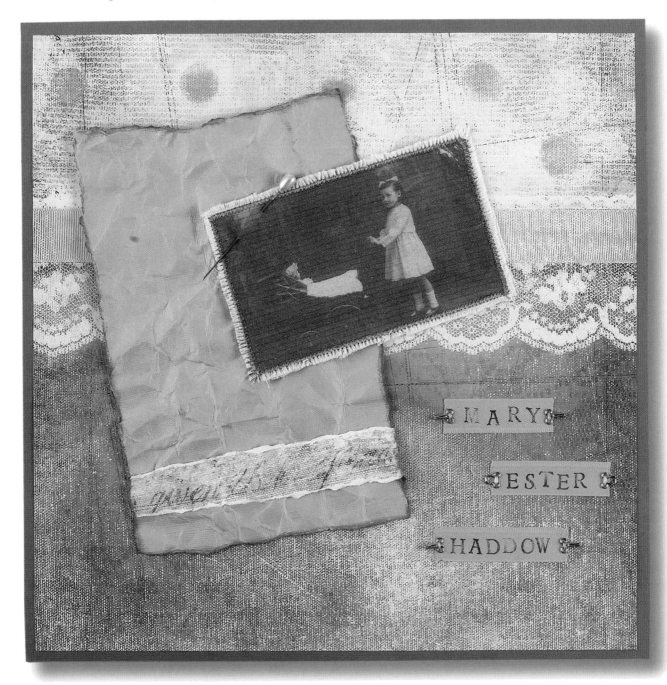

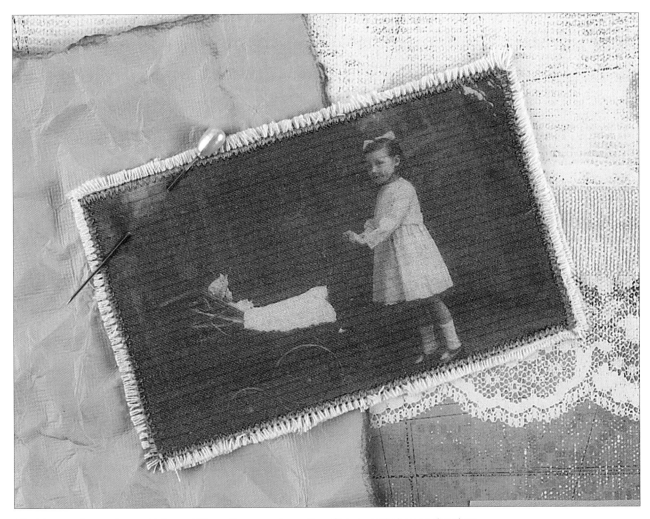

Machine sewing on to card takes a little patience and practice. Set your stitches so that they are not too small, and if you are using zigzag stitch, set it to be quite open. If the stitches are too small or too close together they will cut through the cardstock rather than stitching it. Make sure the tension is quite loose and test it on a piece of scrap cardstock before you begin on your fabric and card. Attach the photograph to a cardstock mat with double-sided tape. If you have printed on to fabric, fray the edges before you stick it down. Start with the needle in the corner of the photograph. Stitch down to the next corner. With the needle in the project, turn the whole mat. Repeat until you have completed all four sides. Stick down the loose threads on the back of the mat. Stick the matted photograph on to your layout. Embellish with haberdashery; I have used a stickpin and hooks and eyes.

About the contributors

 Katie Shanahan-Jones lives in Oxfordshire with her husband and three young children. She has been scrapping since 2002 and has developed an eclectic style. Capturing key moments and telling stories are her aims in scrapbooking. Inks, haberdashery and hardware are some of her favourite scrapping items.

 Kirsty Wiseman is wife to Mark and mum to Ellie. She started scrapbooking in 2004. She regularly writes articles and supplies artwork and photography to several leading UK craft magazines. She also teaches all over the UK and has taught scrapbooking and photography as far as Paris and California.

 Jane Cotter discovered scrapbooking in 2005 and since then has become a scrapbooking obsessive! Favouring simplicity and black and white photography, she concentrates much of her hobby on her family. Jane is a regular contributor to Card Making and Papercraft magazine.

 Sarah McKenna is an Associate of the Royal Photographic Society. She loves all types of photography but has four teenage daughters who feature frequently in her layouts. She has written two books for Search Press, Cropping for Scrapbooks and Eyelets for Scrapbooks and numerous articles on scrapbooking and photography for UK and US magazines. She also teaches scrapbook workshops.

 Joy Aitman has four photogenic children and a tolerant husband who all know how important scrapbooking is to her. She has been scrapbooking for seven years and never believed a hobby could be so life-changing. She has travelled the world, written for magazines and books, taught lots of lovely people and run a successful business. She now works freelance, writing, designing and teaching. She tries to do at least one creative thing a day to keep her sane!

 Mandy Anderson has been scrapbooking for over four years. She always takes inspiration from the photographs, scrapbooking everyday memories as well as special moments. She believes that telling the story behind the picture is important. Her work has appeared in many publications and she has just landed her dream job as the new editor of Creative Scrapbooking magazine.

 Becks Fagg loves to craft for her home, children and just for fun. Having worked as a freelance editor, TV demonstrator, and as PR guru with the company she founded (ScrapGenie Ltd), Becks is an avid scrapbooker. With four photogenic children to keep her busy snapping pics to preserve, Becks holds it all together with chocolate, and lots of it!

 Kate Aldersley began scrapbooking in 1999, and later worked with a scrapbooking company, which gave her the chance to go to America and learn from the best. In 2004 she started her own business, Scrapcanvas, working with paints, canvas and dimensional products. She has exhibited and run workshops all round the country and loves the people she meets. She is married with two children.

 Alison Docherty is a full-time occupational therapist, mother and wife. She enjoys many crafts, and has been making cards and scrapbooking for about six years. Her style is contemporary and she loves to mix different textures and patterns. Alison runs Scrappers' Paradise, a company that organises retreats for scrapbook enthusiasts, and her work has been published in several magazines